Drinking from a Cold Spring

A Little Book of Hope

by Erin Lee Gafill

Cover & Content Design - Tom Birmingham

Cover Photograph - Tom Birmingham

ISBN - 1-4392-4043-4 - Drinking From a Cold Spring

First Edition, Published 2009

Printed in the United States of America.

Published by

26 Letter Press
P. O. Box 459
Big Sur, CA 93920
www.26LetterPress.com

This book may be purchased for educational,
business, or sales promotional use. For
information contact:

Tom Birmingham
26 Letter Press
P. O. Box 459
Big Sur, CA 93920

tom@bigsurarts.com
or call (831) 646-9000

THE BIG SUR FIX

Erin Lee Gafill writes a regular online journal delivered each week by e-mail. Sign-up at her website to receive her essays.

PASSION OF PAINTING

Throughout the year, Erin teaches a workshop series called Passion of Painting. These workshops are designed for working artists and non-artists who are looking for tools to exercise their creative muscles and break through habits that are blocking their personal expression. A workshop schedule is posted on her web site.

www.eringafill.com

Drinking from a Cold Spring

A Little Book of Hope

by Erin Lee Gafill

LEARNING TO SEE

Learning to See

This morning after everyone left the house I lit a candle and noticed for the first time the sound wax makes when ignited.

I lit another candle and noticed it again.

Have I never noticed this before? I wondered.

Last month walking south along Highway One, I saw the most glorious wild lilac flowering shamelessly in the softest blue and white canopy of petals I'd ever seen. It was so beautiful I literally stopped in my tracks. A tree I walk by every morning and have passed coming and going for almost fifteen years and yet had never seen.

A few days later I walked the same road and was half way home before realizing the lilac had disappeared - or (what really happened) I had just not seen it. Again.

I am often struck in painting that I am continually learning to see, and to see again, and again. And that there are periods of not-seeing, of blindness, absence of

understanding, in the process of seeing deeper.

I began by painting what I saw as best I could. At some point I tried to paint what I felt as well as what I saw - using color, composition, and line to evoke emotion, mood, the interior of the self. At one point I just painted color using compositions I imagined in dreams.

This year, I have returned to the landscape on a journey through the heart - what I see, translated through emotion, into something that is and is not literal, is and is not land/scape, sea/scape, sky/scape.

I am trying to paint the way I felt when I heard the wax sizzle and pop into flame. I am trying to describe in paint on canvas the sense of seeing as though for the first time light coming up over the mountains.

It is a sense of the ecstatic, the true, the eternal. And as I paint, I am thinking, I am seeing this for the first time, yet it has been here all along.

•••

Every morning as we walk the light comes up over the mountains, playing against the clouds in the sky, shifting tones across the water like strands of thread through silk.

Each morning we walk under a rising sun, over the swell of waves coming to shore, through the turning of the highway, passed the flowering trees.

Today was a little different. It started with a quick cup of coffee and drive north to the Big Sur River Inn to drop Tom off for an early morning tow.

Pulling into the parking lot usually teeming with

Learning to See

activity, I noticed how quiet it was.

As I waited for Tom to call AAA, I noticed the sounds of the river below, the sound of the breeze moving through the long tendrils of the Cecil Bruner, noticed the roaring silence, and relished the stillness.

Today I felt it.

Spring is upon us - this moment of awakening.

An illumination.

WALKING OUT OF CHILDHOOD

(A response to Marge Piercy's
"The streets of Detroit were lined with elms")

They were churches of trees
I would walk under them
And my eyes would rise enthralled and fat
At wondrous noisy birdsong

They sheltered me like wings,
I passed through them like light through glass,
In prayer in passing hungry and drinking
I lived for those leafy green mornings

Touching the sky with my fingers
Touching the places between the branches
Where heaven shown through and birds wove
In and out, their wings touching sometimes

Walking out of childhood

CHILDHOOD

Childhood

Saturday morning fog rolls in. Outside the trucks are rolling in too, hauling away the week's trash, shattering the silence.

Living as we do above Nepenthe, there is always activity, a buzz of necessary action going on. Looking out my window, I see the morning clean-up crew in navy jumpsuits mopping the red terrace, white towels dangling from their back pockets. The lights are on in the restaurant, glowing yellow against the early morning fog.

Upstairs in the prep kitchen, blueberry muffins from yesterday's baking are handed out to the early birds and coffee is brewing. The ovens are fired up, awaiting brioche loaves and triple berry pies and chocolate chip cookies which will perfume the air all morning.

I grew up above Nepenthe. This life and hum informs my earliest sense of self. My grandmother Lolly would get me and my brother and the shifting sands of

Drinking From a Cold Spring

cousins all washed and under the covers, tucking the sheets fast around us and secured under the mattress before reciting the Lord's Prayer and going back into the living room, back into life and music and drama and grown-up people.

I used to sneak out of bed just to press my ear against the crack in the door, to hear the laughter and conversation a little longer. I wanted so much to be part of it all. You had to watch out for the loose floorboard which creaked horribly. Still does to this day, reminding me of Lolly, and the sound of her steps striding back to tuck me back into bed, the sound of her zories flapping on the floor. A terrifying thrill!

Today fog has shrouded the landscape. There is no sea, there are no mountains. But the sounds and the smells have stirred in me a strange and wonderful remembrance of childhood. Images arise from emotion, from memory, perhaps even from an absence of visual information, allowing another story to unfold.

If I were sitting at my drawing board right now I would pull out watercolor paper, dip a brush into the water and lay down a clear shape on the paper, then touch one color to the water's edge to see what the water would do.

The magic of watercolor is that the water does so much of the work, and in drawing the color across its surface evokes ideas you never knew you had.

The magic of writing practice is you start where you are – observing, remembering, listening - and this simple

Childhood

act of being where you are leads, inevitably, to a place you didn't know you needed to go to, but in following the thread you go a little deeper into understanding.

•••

The first time I saw my father he was standing on a street corner in New York City. It was winter, just before Christmas. Snow was falling and he wore no shoes.

Tony left in 1962 when my brother was a year old and my mom was pregnant with me. He did come back one time, when I was a baby. There is a picture of him holding me, but then he was gone for good.

Sometimes Tony wrote my mother letters she'd read to us at the end of her shift at the restaurant. His sentences were disjointed, the words sprawling across sheets of lined yellow paper, but always with a return address carefully penciled into the upper right-hand corner. His mother Marge's address in Brooklyn. The Catholic Worker's Shelter. Bellevue Hospital.

In one of his letters he wrote that he'd joined the army but didn't like it and went AWOL. I was five or six then, and thought that meant he'd climbed over a wall. He wrote about being on the streets, getting shot at by cops, being chased by B-52 bombers.

"Does Erin still play with dolls?" he wrote. I was fourteen then. His question made me angry and sad. I had never really played with dolls. He didn't even know that about me. That was the last letter we got. He was in Bellevue then. My mother called the hospital, but he'd already been released.

Drinking From a Cold Spring

That was the year I decided to find him. By then Tony had become an obsession, his absence a constant force of sadness and longing in my life, a kind of dark pressure.

I had the letters he'd written and the name of a diner he talked about going to eat sometimes when he had a few dollars to spend. I had an uncle who lived in upstate New York and I asked if I could come for Christmas. It turned out my uncle Kaffe was flying to New York around that time and we made arrangements to fly together. My uncle Griff and aunt Roslyn and their kids would pick us up at the airport.

It was late when we arrived. We drove into the city for dinner. I don't remember what we talked about. I was in my own world of thoughts. I was realizing that I wasn't going to find him.

How could I? A few letters - a few names - what good where they? I was only fourteen. I didn't know how to make my way around the city, hadn't even told anyone why I'd really come.

Snow had started to fall as we pulled up to the curb. A man was standing under a street lamp. He wore no shoes. He was gaunt, with short chopped hair, huge eyes lost in shadow. I remember thinking that he looked cold. I remember thinking, that man could be my father. I watched him bend over to pick something out of the gutter.

Suddenly the car was quiet. My uncles, Roz, the kids. All the chatter died away.

Childhood

"That's Tony," someone said. "That's your father."

I felt my heart freeze. My hand was on the door handle, but my fingers didn't move. I looked at the man standing there, saw him turn the corner, saw him walk away. On the patch of sidewalk where he had stood snowflakes began to fall. I thought someone would open the door, go after him, call out his name, but no one did.

That night we ate spicy cashew chicken in an overheated Chinese restaurant and drank pot after pot of tea. Food kept coming and I ate until I hurt and kept eating. But the pain did not displace the shame. That I had said nothing, that I had done nothing. That I had found Tony, and let him walk back into that vast, cold, lonely city.

I felt that I had failed myself. That I had failed him.

•••

When I sit down to write today, I promise myself I will follow the thread wherever it takes me. Sometimes it takes me into dark places and staying with the thread is like taking a pick axe to granite. Staying with the thread means not getting up and walking away to answer the phone or turn over the laundry or do something I suddenly remember I absolutely have to do. Staying with the thread means keeping myself where I am, being who I am, not turning away, not trying to turn a phrase, just turning the soil over as I dig deeper. It is a kind of excavation.

IN THE GARDEN

In the Garden

This week we've been working hard in the
garden, working with pick axes and shovels,
excavating gravelly earth and hauling in hundred pound
bags of sand. Tom comes home early to dig up pathways
and build raised beds. I have set aside my paints and
brushes and am playing with six-packs of foxgloves and
five gallon rosebushes. We fall to sleep bone tired at the
end of the day, our jeans so stiff with dirt they practically
stand on their own by the front door waiting to be put
on again to tackle the next day's list of digging, shoveling,
transplanting, envisioning.

Today, though, was an in-door day - an arctic wind
blew from the north. At dawn Tom was out in Cachagua
dropping off a bunch of Chi's friends for a five day back-
packing trip and saw the mist frozen on the trees, like a
fine rime on the windward side of the pine needles. Here
in Big Sur the sun was high, the sky blue, white caps

choppy on the water. Customers huddled in their down coats as they crossed Nepenthe's terrace, seeking a table with a view AND the warmth of an inside table.

I fell asleep late in the day and woke up to a bright light on the water, the light stirring in me memories of childhood. There is a feeling here, sometimes, looking south over the ocean with the wind blowing, the sound of the wind in the trees, the trees shaking against the side of the house, as though everything is waiting, as though something is about to be said, or is being said, that we have to stop, wait, look, listen.

There is a sense, here, standing on the terrace looking south from Nepenthe, looking out over the light on the water, feeling the breeze so strong it almost pushes the tables across the terrace, of a mighty power, of a song being sung, the flashes of light across the water conveying some deep mystery.

Working in my garden, I look up sometimes at the mountains and redwood trees, the hawks flying over the deep canyon below, the grey ribbon of highway curving through and beyond. It is beyond beautiful, and I am filled with gratitude to have my little corner to play in.

Back to the garden.

THE HOUR OF KNOWING

The Hour of Knowing

After a night of turbulent dreams, I was reluctant to walk this morning, feeling like there was too much to sort out, that I needed more sleep, and that (as usual) there was too much to do. But Tom had made me a cup of coffee and the sky was bright, and I knew I should, so I laced on my sneakers and headed off.

We walked three miles south under wintry gray skies, the light all pearly and exalted. The brightness of the rising sun was diffused through veils of atmosphere, drawing my eye up beyond the tops of the redwood trees, beyond the mountain crests, beyond the black birds perched on the power lines. After a few minutes trudging along, my spirits lifted and I couldn't remember why I had been so reluctant to get up and walk. By now I know this will almost always be true. I may start reluctantly, but am always glad I made the effort.

Tom reminded me of how we started this early

Drinking From a Cold Spring

morning tradition. It it used to be 6:30 AM - - when the kids got on the school bus, we'd head south. Chi is 24 now, and Emily is 18, so our morning walk has become a kind of structure in our day for many years now.

There is a quality of talking and not-talking that takes place during these walks that is unique, and uniquely helpful. This is the time where we dreamed big dreams, and started bringing little notebooks along with us to capture all the ideas so we didn't forget anything. We got so busy that we started NOT bringing the notebooks along – even stopped walking for a while – for fear of becoming completely overloaded with ideas we felt compelled to make realities.

This walking time allows us to be together as partners, as friends, as human beings who share a life, family, goals, yet are not compelled by any of those roles during this sacred hour.

It is an hour of being, of breathing, of walking in beauty. Because we do this every day, we know we will have a chance to catch up with each other in the midst of days when we can barely see straight. We know there is light at the end of the tunnel.

So much of our lives are driven by projects, deadlines, unexpected forces. It is incredibly comforting to have a few things that are givens, a few things that we can build in to support everything else we want to leave our lives open for.

In thinking of our day as a canvas, I see that this hour is where the composition is visualized. In this hour,

34

The Hour of Knowing

impulses flicker across my consciousness, things to act on and things to let go of.

As we walked this morning, my eyes were drawn up again and again. I felt the light of the sun filling me, and when we stopped at the halfway point I stretched for a long time, filling my lungs with clean air. The road was quiet. When we turned to walk back home, I felt like we'd been lifted out of the ordinary for just long enough to be able to return to it renewed, refreshed, re-energized.

Now, over a second cup of coffee, I take a pen and a piece of paper and begin to sketch out what needs to happen to make the day work. Somehow it has all gotten itself sorted out during the hour on the road.

Drinking From a Cold Spring

Drinking From a Cold Spring

Today we walked early. The sky was clear, the ocean calm, the air sharp with cold. We noticed a half mile beyond Deetjen's that no cars had passed, there were no surfers checking out the waves along the road, in fact a marked absence of signs of life save for a peregrine falcon on the telephone wire just south of Nepenthe.

We were almost to Fuller's Beach when the first car broke our reverie – a mom driving like a bat out of hell, heading south to drop off her son (we guessed) at the nearest school bus-stop, returning just as fast minutes later, the seat next to her empty (hypothesis confirmed).

As spring gears up, we are emptying out -- our son heading off for a two month road trip across the country, our daughter moving toward graduation from High School. Planning our new garden, half of the work was taking everything out, and the removing and emptying and purging and letting go continues to be the hardest part.

Drinking From a Cold Spring

Tom might say hauling in two tons of stone and two tons of sand, and laying the pathway and patio, and digging out the clay and rock underneath, is the hardest part. But for me, standing in the midst of all the STUFF trying to decide what to do with it all -- what to keep, what to give away, what to throw away, what to replace with a hardier specimen or not replace at all -- is even harder.

What is happening in the garden and in the spaces around the garden and the rooms which open into the garden, is a similar kind of organization, dislocation, letting go.

On the one side of letting go – of silence, of empty space – is loss, sadness, fear. On the other side, there is a deeper breath, peace, and an opening to light.

All the succulents, the spider plants and half the geranium starts I purged have already gone on to new homes. Now when I walk into the garden I see lilies and primroses and ferns thriving in shade and deep rich soil, the Cecil Bruner twice the size as when we planted her last month and fully blooming, entwined with purple Clematis that seems to grow a foot a day, and overnight.

The transplanted ferns are unfurling their fresh spring green above the soft violet pansies, the babies tears holding down the top soil. The blood red Japanese Maple holds her station against the climbing jasmine. There is nothing left to do here but water, feed, and enjoy. Standing in the garden now after weeks of hot hard work, there is strange feeling of both accomplishment - and emptiness.

Drinking From a Cold Spring

What will I fill the space with now?

I am waiting, sitting with the emptiness, knowing that this too, as all things do, will pass.

UNMOORED

I am in that watery field a milky way
devoid of stars of gravity of maps or moorings,
floating burning or frozen as one by one
The house empties out, garden grows quiet, birds stop
singing

The sun's rays dissolve into twilight before stars

Do you remember how you used to ask me questions
And I always had the answers?
Now my heart beats hummingbird fast in my chest

I am standing in that between place
Between knowing and not knowing
Unmoored, waiting for the first star in the night's
sky to come out, after the sun has gone dark

coiling recoiling trying not to try
wanting not to want, a quiet unquiet place
and the water drips in the sink and the dishes are
undone and the laundry flaps on the line

as though all is as it always was

BIG SUR AND THE WILD STRAWBERRIES

Big Sur and the Wild Strawberries

Sunday morning we walked to Molera Beach,
picnic lunch in hand. Along the way we stopped
to pick wild strawberries that grew between clumps
of pink beach aster and golden California poppies.

The walk meandered through a river-side
meadow overgrown with tall grasses and scrub, then up
along the sandy cliffs that separate the beach from the
valley.

Halfway to the trailhead we saw a buck grazing in
the shadow of a tree and stopped quickly, just as the
buck stopped munching to watch us. Within seconds my
nephew William had his sketchbook out and had drawn
a picture of the buck. At almost six years of age, he grasps
all the essentials, and quickly - four stick legs, the lines of
the buck's antlers and its long oval-shaped body. I envy
his lack of hesitation and his speed!

The sun was high and there was a cool breeze

coming in from the ocean when we finally made it across
the boneyard of sea-worn logs that block the creek mouth
at the foot of Spring Trail, and we sheltered between rock
and driftwood to eat our picnic.

Sun. Wind. Ocean. Sand. Driftwood and smooth
stones. Digging in wet sand to make a castle, we found
a buried rope. We pulled as hard as we could and dug
deeper, wondering what it was attached to and how
long we'd have to dig before we got to it, then collapsed
laughing when we finally reached the end of the rope,
which was just the end of the rope.

On the trail back we moved slower. There were still
a few wild strawberries to gather. We saw no deer but
plenty of bobcat spoor. We had to chase William back to
the car as every curve in the path became an adventure
and a race and a reason to fly ahead.

Traveling with William is like traveling back in
time – to when our children were his age, a golden time
I remember being in the midst of and always trying to
hurry along. And it takes me back to being a child myself,
the sense of time without end that a day at the beach had,
the sense of goodness and rightness. Nothing ever tasted
as sweet as cold creek water. No sleep was ever more
refreshing than a nap on a sunny day after a long hike to
and from the beach.

The smell of sand in our palms. Eating home-
made sandwiches and Holly's chocolate chip cookies and
closing our eyes to bask in the fullness of it all. What do
you take away from a day at the beach? A moment so full
it is brimming with eternity.

50

BEGIN WHERE YOU ARE

Begin Where You Are

It's been one of those days. Everywhere I turn there is so much to do I don't know where to begin. Finally I sit down, take out pen and paper, and start making lists. I block out two hours to work in the garden, an hour to exercise, four hours to work on new paintings, and a list as long as Sunday of phone calls to make and e-mails to return.

That out of the way, I promptly begin doing everything that WASN'T on my list -- laundry, dishes, purging and sorting magazines, reading old mail. Time ticks by. My lists of lists remain unblemished, no check marks, no progress, even though I have been spinning like a top since the sun came up.

Yesterday, wisely, I set my timer for 20 minutes, lit a candle, and sat down quietly to meditate. I noticed my mind running after things I should have done, could have done, would have done. Then I came back to

my breathing. Breathe in. Breathe out. Notice mind wandering. Begin to ponder imponderables. Breathe in. Breathe out.

The big time gulp for me today has been trying to learn new software on the computer. I took hundreds of pictures on my last trip to Mexico and want to put them on my web site, and e-mail them to friends, and have a few as references for my studio paintings. As I stumble along, learning by trial and error, I feel like I should be better at this.

Why don't I already know how to do this?

I'm thinking, EVERYONE knows how to do this.

I'm thinking, what an IDIOT I am!

I go along in this vein for a while, castigating myself as I make one mistake after the other, losing images, finding them tagged with the wrong names, trying to separate out one group from an other only to have everything turn up in the same batch again and again.

Then I realize something.

I don't know how to do this because I've never done it before. I've always relied on Tom or Emily or some techno-savvy member of the family to upload and download and resize and e-mail images. And Tom and Emily learned by doing exactly what I'm doing now. Trial and error. Clicking here, clicking there, making mistakes, learning their way into it.

I want to be further along on this learning curve than I am. But I can only begin where I am. And this is where I am. At the beginning. Learning my way into it.

Begin Where You Are

You begin where you are. Where else can you begin, anyway? Somehow this thought eases my mind tremendously and my frustration, impatience, and self-punishing remarks dissolve. I make a cup of tea and settle in, actually enjoying the process of reviewing these images one by one as they flicker across the screen. Instead of bemoaning how long it takes, I notice each image and remember what was going on when I took it, reliving my week away.

And I realize something else.

This is a season of change, a season of milestones. As I settle in and slow down, I feel a deep sadness at the passing of time. Our son Chi is on the road with his girlfriend Lorissa, checking out new places to call home. And our youngest, Emily, is graduating from high school in less than two weeks, on the brink of real independence.

Sadness on the edge of anticipation. I am looking forward to an opening up of space and time. If I were drawing a picture of child rearing years, it would be incredibly crowded - endless diapers, sleepless nights, holidays, beach days, temper tantrums, cooking meals, house cleaning, schools and play dates, parent club meetings . . . what lies ahead is mysterious, but somehow spacious. At once open and inviting, and at the same time curiously lonely and wistful. I am already missing her.

Somehow in all the rushing about, these feelings and thoughts manage to hide out. Now, slowing down, they resurface. I look at them as though they are someone else's thoughts.

55

Drinking From a Cold Spring

Hmm.

Breathe in. Breathe out. Notice where the thoughts go, notice the feelings that rise and fall.

I didn't get much done today. But it is something to know that today, this is where I am.

Back to the studio.

BEGINNING TO BEGIN

Beginning to Begin

I am heading off for three days of painting in Hollister and San Juan Bautista and so spent the better part of the day beginning to begin.

I cleaned out my turpentine jar, scraping off years of gunky oil so that the lid would actually close and filling it with fresh mineral spirits. I picked brushes - long handled rounds, brights, flats, a few watercolor brushes for detail. And I sorted paints, choosing only the colors I would use on the road, a limited palette of reds, blues, yellow, greens and fast drying white.

My studio practice has pushed me bigger and bigger and bigger - this week working on a 4' x 6' canvas using 3" brushes, a plate for each color, so had to dig to find small canvases and boards. When Chi left town he left behind a stash of wooden supports he'd cut down to paintable sizes, and so I chose these, priming them in soft neutrals, letting coats of white gesso dry then rubbing in yellow ochre, earth green, sepia.

Drinking From a Cold Spring

When you paint out of doors, you have to be really organized - thinking not only about what you need to do the work, but also about taking care of your body - a hat, sunscreen, long-sleeved shirts to protect yourself from wind and sun, plenty of water, food, garbage bags for the paper towels you'll be using to wipe your brushes, and lunch!

You have to think about shade, so that the sun doesn't distort the brightness of your painting - and there isn't always shade where you find your scene. So maybe that means there's an umbrella to bring, and a stool for perching, and something to set your stuff on - the turpentine and the brushes and the bottle of water, paper towels . . .

If you are lucky enough to find a spot to paint near your car, you can really use the car as a home studio - but if you are heading out into the hills, you think carefully about what you bring. Essential, to me, are a broad-brimmed hat that sits snugly on my head, lunch (man! Do I get hungry out there), really sturdy boots, and an easel that can contain brushes, paint, AND palette . . . one box or backpack to carry the rest in.

So much to remember!

But as in so many things, the preparation is actually the work. By the time I am where I am going, set up, canvas on easel, paint on palette, scene before me, I am free to enter into the painting with abandon, leaving all the stress and fear at the door.

As I go in circles, gathering together just what is

Beginning to Begin

essential and continually pulling things out that I don't need for this trip, I realize that this is actually what I do when I am painting. Gathering the essential. Leaving the rest out.

When I look at the work at the end of the day, or the weekend, I am not looking to see if the Mission bell tower is drawn "just right" or if the rose bush really had that many roses . . . I am looking at what the painting was about, and whether I got that.

I am not seeing rose bushes and trees, but shapes. I am thinking, not was this tree really this shade of green, but do these overlapping shapes and colors create a design that brings me into the emotional center of the experience.

In reviewing paintings, I try to sneak up on them and "get" them all at once, seeing the "gestalt" of the painting and not looking at it as many parts adding up to a whole. If the angle of a barn roof or the brightness of a distant pasture jumps forward, then I'll go back in and work on it. Otherwise, I leave it alone. I know that my favorite work retains the spontaneity of first impressions, with the structure of good planning.

Good planning. Another part of beginning to begin. Once on site, I do a series of tonal studies. Sketches. Color swatches . . . how does THIS orange look with THIS gray-blue. Finally picking a design to work out on a small scale. Do a half dozen of those. Pick one to do bigger. Don't go back - go forward, learning your way into it by doing another, and another.

Drinking From a Cold Spring

I'd rather end up with a dozen studies than one painting
I've struggled over all day.

I used to chafe at how long it took to get
started. Now I get it - it's actually the beginning of the
painting. Without it, I'd be struggling a lot more with the
brush in my hand.

The decks are clear - the car is loaded. One last
circling of the studio, grabbing extra water, a light jacket,
making sure I have the cell phone and the maps, money
and car keys, kisses for the family - and away I go!

PAINTING PLEIN AIR

Painting Plein Air

J ust back from a fourth day plein air painting -
reeling from what it is to do this.

This morning, Branham and I met at 10 AM at the
bottom of the Old Coast Road, drove up a mile to a pull-
out where the wind was so fierce we were quickly back in
our cars heading down again.

Found another pull-out a few hundred feet above the
highway, made a wind-barrier with our two cars, and set
up easels, me looking south, Branham north-west.

There was wind, there was sun, there was the bird's
eye perspective looking down on top of the old barn at
Molera, the rounded forms of trees and shrubs clinging
to the side of the hill, the redwoods in the distance, and
ridge after ridge dissolving into high blue sky.

There was bright hot white light, birds flying below
us, a brilliant deep blue sea flecked with white caps,

the eucalyptus trees a soft broad canopy above the old dairy barn, and before that a white dusty road cutting through a swath of soft waving grasses, and the highway, meandering, dotted with cars.

There was silence and the roar of wind, no clocks ticking, no phones ringing, yet urgency and import nonetheless. After three days of painting Hollister, San Juan Bautista, Tres Pinos, feeling like I was really getting somewhere, I felt back to square one - the values and difference washed out, the colors too bright or too dull, the task of capturing what it looks like and what it feels like impossibly large.

Just get the shapes, just rough it in, I told myself, as the wind lifted the easel off the ground and flapped the canvas support bar over.

Just notice the difference between things and paint that, I thought, lunging for my roll of paper towels as they went flying into the scrub.

Just keep it simple, I told myself, as I sketched in barn, outbuilding, willow tree, field, road, highway, cars, bank of shrubs, tree line, and five distinct receding mountains. Simple? What was I thinking? Not simple. Not even possible.

What I have learned along the away?

Set up your easel in the shade. That way the values of the paint on the palette and the paint on the canvas are the same so you are not adjusting for all that natural light bouncing around everywhere.

Painting Plein Air

Did I do this today? No.

Keep it simple. No more than five shapes first. This is my old rule from teaching kids in the schools, where you've got to work quickly to get anything done in 45 minutes (or less.) Five shapes, i.e. sky, mountain, tree, field, flower.

Did I do this? Today?

No. I wanted to paint *Everything*.

What DID work was having a painting companion. Branham and I each experiencing this wild Big Sur beauty with relish, each exploring, trying new ideas, coming to the process fresh. Because we had both committed the morning it was harder to throw in the towel. Branham's freedom to move on to a new canvas helped me feel like I could move on, too - getting out of the first one before I started going backwards.

In between companionable silences, we talked about our lives and not for the first time I was struck with the idea that what we paint is what we are - that we are processing visually the same things we are struggling with in our "real" lives. It hit me suddenly that the decisions I was having trouble making in my compositions were the same problems I was having at home with work and family and friendships. Too much on my plate, what to let go of, what matters and what doesn't, not wanting to make choices.

It was a good day. I hung out with an old friend and had a couple of hours of therapy and philosophizing

Drinking From a Cold Spring

rolled into one . . . never lost my hat, got at least twenty minutes of sun, and came home ready to tackle something easy . . . like building a new perennial bed in the garden! Hah! All this plein air painting makes shoveling rock seem like a piece of cake.

CULTIVATING CREATIVITY

Cultivating Creativity

Creativity is something you can cultivate . . . like a garden. As in a garden there is the soil, and there are the seeds.

Last summer I went to Rancho La Puerta in Mexico for a week. Every day I walked in the mountains, practiced yoga, ate organic food, attended lectures, napped, read, swam and wrote.

By the end of the week I felt utterly relaxed, alive, restored to a sense of rightness that had somehow slipped away.

I tried to pay attention to what made me feel so happy there, and asked myself how I could take it home with me.

I started by looking.

The walls of my room were painted pink, the bedspread a happy yellow, the cushions embroidered with flowers in turquoise, magenta, lime green. Next to

the soap in the bathroom lay a sprig of lavender. Even the toilet paper was tied in a pink ribbon.

Someone was taking very good care of me - - care that my senses were filled with beauty, that there was nothing to pull me away from rest, relaxation, and the work of restoring myself to myself.

I thought a lot about how the Ranch had cultivated the sense of well-being that was flourishing within me, how thoughtfully schedules were arranged, and how purposefully.

I came home from Mexico with a commitment to certain things to do and NOT to do . . . committed to practices that would create good soil for the seeds of creative work to grow and flourish in and ways to keep weeds from getting a hold.

Here are some of the things I took away from the Ranch:

Color makes me happy.

I like flowers in every room.

Taking care (and time) with the food you eat is a way of taking care of your self.

Writing plans down makes them come true.

A morning walk sets up a better day than an extra hour of sleep.

Remove desperation and add inspiration: more going to seminars and less complaining, more good books and less bad TV, more time with inspirational people and less time with people who live life as though it's someone else's fault.

Cultivating Creativity

What does all this have to do with creativity? For me, everything. Balance, health, rest, peace, and beauty are my keys to creating a daily painting practice.

My plans for the holidays include a commitment (which means writing it down) to health (walking and yoga) and spending time in nature, taking time to cook good meals for my family, and spending time alone every day just breathing, which restores my fractured mind to a peaceful place that makes much better decisions than when I am bouncing all over the map.

I'm removing desperation by saying no to over-scheduling and am adding inspiration by studying color and still life painting with my amazing uncle Kaffe, my Christmas present to myself.

And I will take the time to put flowers in every room.

SMALL ACTS OF KINDNESS

Small Acts of Kindness

Considering where we live, an hour from the closest grocery store or movie theater you might think we are often lonely.

But it not physical distance from a town (in other words, other people) that is isolating. It is the sense that your life doesn't matter. Not to you or to anyone else. The sense that what you do, what you think and feel and want, doesn't matter. The fact that so often when you begin to hope for change you quickly talk yourself out of the change you were about to make. Because after all, what difference does it make?

I believe with all my heart that what we do does matter, and that we need each other to break out of that cycle of self-defeating self-isolationism. Even living in a city or largely populated area, working and networking, socializing and prioritizing, putting your nose to the grind stone, clicking your way through your

lists, you can begin to dig a groove in your own mind that keeps you separate from others.

Keeps you separate so that you can focus, accomplish, push forward. Keeps you separate so you won't be drawn in, or drawn to, someone else whose needs might distract you from your own.

Living in Big Sur has taught me that reaching out to others is what we do best, that connecting to others in times of need is where our spirits shine the brightest. In fact, it's almost easiest here in a time of natural disaster, when the river rises and the roads are closed.

During times of crisis, people turn to one another in an extraordinary way, to ask for help, to offer help, to cook meals for stranded families, to show up at one another's homes to dig the culverts clear of debris or clear the roads of fallen trees.

During the el Niño winter of 1998, local restaurants and hotels lent their kitchens and lobbies and dining rooms as classrooms for stranded students . . . people came out of the woodwork to teach when the teachers couldn't get over the slides at Hurricane Point.

But it is the ordinary times of reaching out to one another I am thinking of today, with no hurricane or mudslide or crisis to precipitate action. It is the times of choosing to write a letter to a friend who is ailing, or e-mailing a tip to someone who needs a little help along their path, or an invitation to a person who is new in town to come by for coffee and meet some of the neighborhood.

Small acts of kindness. I am thinking of Helen

Small Acts of Kindness

Morgenrath, who has invited so many of us into her family tradition of candle-dipping and in so doing has given us a connection with one another that is an enduring bond through all seasons.

Years ago, Helen worked at Nepenthe as a waitress. There wasn't a lot of money and there was no electricity where she lived. At the end of her shift, she would gather up spent candles, take them home and melt them down with her kids, fashioning new candles to light their home. As the years went by she started buying wax and wicks and inviting friends to come by and dip candles with her. Now the tradition is carried on by her children and their children and the guest list counts into the hundreds.

I started going to Helen's candle-dipping parties when I was in my teens. By the time my kids were in their teens, the tradition had become solidly their own. In fact there were many years when I stayed home and Chi and Emily came back with stories of old friends they'd seen and gorgeous multi-colored candles wrapped in newspaper, perfect for nights when the power was out, or as Christmas gifts.

This year I went to candle dipping alone. Tom was working, Emily too busy, and Chi and Lorissa settling into their new apartment in Brooklyn. Walking the circle, dipping my two hangers full of wicks in and out of the hot wax, I felt waves of sadness pass through me. Waves of remembering – myself as a teen, as a young mother, as a mother of teens, now a mother whose children have flown the coop, or were flying.

Drinking From a Cold Spring

Then I looked across the circle and saw my nephew Will who had come for the first time with his mom and dad, and my mother sitting talking with friends she hadn't seen in years. I saw Helen sitting quietly, watching her children and grandchildren carry out tasks that they each seemed to know like the back of their hand - checking to see if the temperature of the wax was too high, making sure new arrivals knew were the potluck went, keeping the pot of mulled wine hot and spicy and full, instructing newcomers in the method of dipping and walking, dipping, and walking, so that between each hot dip the wax would cool enough to receive the next coat.

As guests arrived, there was as much talking and catching up and flirting and hugging and laughing as there were candles dipping . . . Will went out to play with the new crop of 5 year olds, my mom invited someone she'd just met to her monthly knitting circle, my sister-in-law made her Christmas candles for the first time, and everyone asked about Chi and Emily and Tom. I thought – how loved they are, how missed, and how lucky. Not lucky. Blessed.

We are blessed to have each other - to have friends who reach out to us - to know that this is what makes life here great, to know that in each dip of the candle is a prayer for love, for connection, for communion.

When I light the candles, I imagine these prayers being released. I imagine my children can feel my love reaching them, making them a little less alone, a little more peaceful, knowing that their lives make a difference, that what they do matters, that hope is what gets us out of bed every morning.

PASSION OF PAINTING

Passion of Painting

B egin where you are.
 Art making is an act of inquiry, more about process than product.

Start loose and stay loose as long as you can.

Get in and Get out.

Choose subject matter that excites you to draw out your best, boldest work, work that taps into your whole intelligence: mind, body, heart, spirit. How do you know what this subject matter is? It is a process of inquiry.

Work with abandon. Criticizing your work while creating it is like driving a car with one foot on the gas and one foot on the brake. Be nice to your car. Be nice to yourself.

Think of each painting as an exercise, an exploration, a dialogue with what is. Don't second guess your marks. It is better to do 20 quick sketches to gain understanding than to labor on one larger piece that you may never get "right."

Drinking From a Cold Spring

When you start comparing yourself to someone else, notice this. Then let it go. When you start comparing your work to other work you have done, notice this. Then let it go. When you start criticizing your work, notice this. Then let it go.

Comparing is human. The only thing you need to compare your work to is what your intention for the work was.

Walk away from your work from time to time. You will come back with fresh eyes. Sometimes when you are struggling to know where to go next, taking a break can allow you to see that the work is done.

The work of making art is the work of inquiry. Where am I? What do I feel about this place? Who am I? What matters to me? What matters?

Look after the big pieces and the little pieces will look after themselves.

You learn to paint by painting. Time in the studio is time into a relationship, with your materials, with your subject matter, with your questions, with yourself.

Keep your head in the work and stay out of the results. (I stole this idea from my friend Annie Jacobsen, and I'm sure she wouldn't mind. It has saved my sanity many a time!)

You paint not to tell but to ask. If in doubt, ask your painting - what does it have and what does it lack? If in doubt, stop and start something new. Repeat as necessary.

During studio time, do not destroy your work. Work fast, make a lot of work, let work accumulate. Looking at

Passion of Painting

old work helps you see new work more clearly.

Allow yourself to breathe slowly and paint quickly.

Be kind to yourself.

Speak kindly to yourself.

Simplicity is bliss.

The best things in life are free

Do what you love. Period.

Paint as though your life depended on it. Maybe it does.

Let go.

Remember who is doing the work and get out of their way.

Stay as loose as you can, as long as you can.

CHRISTMAS

Christmas

The phone rings early, 4 AM Christmas morning.
Tom is up and answers.

"It is your father," he says. "He has gone into the
hospital. They say they'll call back later."

I am awake now. It is Christmas morning and
we have the family coming over for breakfast and gift
opening. Emily is home, Kaffe and Holly are coming, my
cousin Nani and her kids . . .

The phone rings again a few hours later. We are
gathered in the living room, laughing and eating,
unwrapping gifts in our pajamas, and then I am grabbing
the phone, listening to a voice 3000 miles away through
the crackle of static telling me very little but nothing
good.

I call back from the other room, am on hold then
patched through to one person after the other until

Drinking From a Cold Spring

finally Tony's nurse is on the line telling me he is sedated, sleeping, in no pain.

I call again and again, pay for a phone line to be opened in his room, but when I call that number there is a recording telling me this patient is not receiving calls. Back to the nurse's station.

"Please tell my dad I love him, that I love him," I say. I am crying so hard and embarrassed to be so distraught. She says she will tell him, and her voice is kind and patient. Later I call back and get another nurse. "When my dad wakes up, please tell him I love him," I ask her. She tells me he won't be waking up.

The next day I am at Abrego Print and Copy making fliers for a workshop and keep interrupting my transaction with the clerk to take the calls on my cell phone which only has enough bars if I stand in the corner of the shop wedged behind two self-serve copiers and a filing cabinet.

It is my father's doctor. I cannot understand his name and keep asking him to spell it. I don't know why it matters - it doesn't matter - but I am trying to find a pencil to write his name down and keep asking him to repeat it.

"I'm sorry," he says. "your father has passed." Or this is what I think he says. His accent is thick, I'm guessing Indian. Then he asks me if I am in charge of disposing of Tony's body.

The man at the counter is looking annoyed. Several people are waiting but it seems he cannot help them while

Christmas

I am on the phone.

I don't know what to tell the doctor.

I am three thousand miles away.

I barely knew my father. I am not responsible.

"I'll talk to his nursing home and get back to you," I say, trying to sound competent, and hang up.

I pay for my copies and drive back to the workshop.

Tom takes over everything – calling the hospital, the nursing home, funeral home. I track down Tony's sister - there is the workshop in process, Christmas and birthdays, and Emily is heading off to college in a few weeks, and life rushing onward.

We make decisions.

There is no estate to haggle over, no property, no possessions. There is a box with a few personal effects we ask for but they do not send.

Tony's ashes arrive in a box within a box. I keep moving them from one place to the next, in the house on a shelf, outside on a chair, finally in the garden under the camellia tree.

"When will you bury his ashes?" Tom asks me.

I tell him later today.

Or tomorrow.

Or when we've got through whatever it is we're in the midst of.

Or in May when family are here who knew him and we'll have time to plan a celebration of his life.

But I do not bury his ashes. I don't know what I'm waiting for, but I'm waiting for a moment when it feels

Drinking From a Cold Spring

like I will know. I don't want to throw his ashes to the wind - his life was so scattered already. And I know, because I asked him once, that it wouldn't much matter to him. "I'm over it," he said to me on our last visit. As in, I'm over life.

And there is the other question. Where to bury him? I ask his sister, and my mother, and my brother. Finally, I realize, the decision is for me and when I am ready to make it, I will.

Tom builds the box a shelter out of mosaiced tiles from an old art project and we light a candle and place it in the dirt between two stones. Camellia blossoms fall onto the box throughout the winter. Tom's sister Meg sends a beautiful card of a Buddha covered in snow and we place it next to the box. Winter rains wash the colors of the card away. The Buddha covered with snow grows paler and paler.

SAYING NO

Saying No

Choosing one thing means giving up something else.

Change comes at a price. Embarking on new projects means letting others end, die, or go into hibernation. Without making those choices, we end up with too much on our plate, going in too many directions. We are overwhelmed, exhausted, wondering where the bus went that hit us.

For most people, January is a good time for beginning something because everyone else is starting a new phase, too. It is a cultural ritual to make a New Year's resolution, to turn over a new leaf, to mark the start of a project or the end of a bad habit.

For me this year is poignant in the sense of endings. My father died the day after Christmas. Though I only knew him in the last decade of his life, ours was a relationship that I cherished. Saying goodbye to Tony is bittersweet.

Drinking From a Cold Spring

Another momentous transition is marked with my youngest child turning 19 and the next day moving away for college. That she is ready to go, to start her own life in this way, is a kind of harvest.

Or at least that's the way I think it's supposed to feel - in fact, it is much less clear cut. Questions that I won't know the answers to for years to come circle in my head as I find myself sleeplessly replaying conversations, decisions, turning points.

In the end, I have to let go.

With my father, I have to let go of what I wished for but what was not to be. With Emily, it is letting go of a stage of parenting a child who always seemed at least two steps ahead of me, and allowing another stage to emerge. Not clear cut at all.

What is clear is that every day we are given the blessing of a new chance, a fresh start.

Some things that help me approach the New Year are spending some time each day in silence, or meditation.

Allowing myself a certain number of minutes to observe all the shenanigans of my mind as it insists on projecting itself backwards or forwards. Eventually, hopefully, a deeper part of my mind emerges that makes better decisions, that knows that now is what is, and that is willing to let go of the rest.

For this New Year, I wish you peace, prosperity, and the pleasure of doing work from your heart.

A POEM FOR THIS DAY

January 20, 2008

I am so life and death today, so total, extreme,
dramatic.
I am the mother who has lost her father
the daughter who has lost her daughter
Equating dying with leaving, implying losing as though
I had her to begin with, and is loving someone having
them?
And yes, I am overstating my case, but
time is out of joint
there is no knowing, no answers I don't even know
what the questions are
find my mind looping around can't get traction
but outside the wash hangs on the line
the garden is in winter disarray waiting patiently
to be remembered
a pot of beans set to soak in the kitchen, I remember
when I used to write poems over the steam rising from
the pasta pot, trying to get it all in - the dinner, the poem,
the crying baby, afraid I was losing everything, my grip,
my cool, my self.
Right to be afraid, for all is lost, and found in the
losing.
So many years later, here we are again,
as we were then,
beginning

PUTTING PAINT ON CANVAS

Putting Paint on Canvas

Two weeks ago we had snow. Today we are in T-shirts and shorts, enjoying the warmth and sun and blue skies. Narcissus are pushing up in the garden, I actually need to water, and am feeling the urge to go to the nursery for a batch of new color.

Instead, I am disregarding the garden, laundry, and dust bunnies and putting paint on canvas.

Tom calls mid-day to ask how things are going.

I say, "I'm putting paint on canvas."

He chuckles, and doesn't press the point.

That's about all I can say, early into a new series. Putting paint on canvas, re-learning how paint feels under the brush, how form emerges out of light, how ground pigments in oil become golden mountains, breathing trees, a sky just before the sun goes down.

It is a kind of magic.

TODAY HOPE LEADS

Today Hope Leads

When my grandmother first started coming to Big Sur she was a little girl and there was no highway. They must have taken a carriage part way, from Carmel to Little Sur River, and then traveled the rest by mule.

In her thirties Lolly returned with her husband Bill and the children to buy the land where Nepenthe now stands. I think she was drawn back to the beauty and the freedom of life here just as we are today.

In a letter to the Big Sur Historical Society, Lolly wrote: "When I was a little girl my grandfather used to bring us to Big Sur along the country road, which winds its way above Bixby Bridge and comes out at Molera Ranch.

"We used to stay at the Pfeiffer Campground, in tent houses. One day I was walking down Sycamore Canyon when I ran into a whole bunch of pigs. I became scared

when all of a sudden a snorting huge pig charged at me. I ran & ran until I saw a small cabin - I came crashing into it and there sat a hunter skinning some animal - He must have been surprised to see me - He rose to the occasion & got the pigs back into their corral - That was Brazil's ranch at Pfeiffer Beach some of those old cabins have been long gone. . . .

"We also used to have large picnics. One of our favorite spots was the beach below Nepenthe. We'd climb down to the beach in the morning and stay until late at night. I am sure they were planned for full moon late nights. When we bought the Log House 30 some odd years ago I did not realize that we were above that beach. We'd pick corn fresh from a ranch & cook it in boiling water over a glorious beach fire."

In the log cabin where Lolly and Bill raised their five children, the house where I now live, there is an enormous wooden box with an extremely heavy lid. The box is lined with tin and larger than any doorway. It was built to store provisions in and to keep the grizzly bears out. There are no grizzly bears now - and the highway loops like a gray ribbon through the landscape, bringing in travelers drawn to the glorious natural world that is our home and habitat.

Now the highway allows us easy forays into civilization, for work and school, for seeing town friends, to partake of music and theater and films, and to buy groceries and propane and candles against the inevitable power outage.

Today Hope Leads

When I was little, town trips were once every few weeks. Now we drive the coast road on an almost daily basis. Our work takes us out of Big Sur, and our longing for the beauty and calm of this sanctuary brings us home again.

It is still winter. The gutters and gullies, culverts and rivers and creeks are running high. Outside a cold breeze blows, yet the garden is full of pink cherry blossoms, and the white almond is flowering. As though spring and winter were dancing with one another, leading, following, joining in a twirl.

Chi calls from New York to say that he has asked Lorissa to marry him, and she has said yes. The joy in his voice is like a balm. There are no words.

Winter brought death and loss, spring beckons with news of weddings, recovery, rejoicing.

Today, hope leads.

TONY

Tony

I try to write about my father, but it is never
enough.

If this were enough, it would include the longing to
know him and be known by him, and the haunting his
absence lay on me in my early years.

It would have the letters he wrote to my mother
after he left her and a list of the places he hitchhiked, the
names of the kinds of beers and bourbons he liked to
drink, the street corners he slept where he got shot at by
cops and fled B-52 bombers that only existed in his mind.

I wonder what watching 9-11 unfold on the TV
screen must have been to my dad, whose medication by
then had pushed the voices of paranoia deep down but
not (as he told me once) away completely, no he said,
nothing could do that, not even Lithium or the miracle
drugs that came later.

There would have to be a list of the drugs they gave

and the nurses who bathed him and the soup kitchens he
scrounged for meals and the number of times he tried to
convince someone he was crazy so they'd give him a bed
in Bellevue and the names of the social workers who kept
releasing him into the streets.

His story would include joining the Army for the free
clothes and hot meals it promised, and his going AWOL
when he realized he'd never be able to kill anybody, and
the pursuit of the Jack Kerouac and Neal Cassady he
read about at Columbia that led him to California, the
burned tawny hills of California and the sobbing canyons
and the long winter when he met my mother and got
her pregnant, and my grandfather, the shotgun and the
wedding, the wedding night with my mother throwing up
because the room was freshly painted and it made her so
sick.

The story would have to know how it ended and
I know now a few things I did not know when I began,
how it will end, at least his body, the broken frail body
shot at and run over, addicted and toothless, the body
aching for the morphine drip with instructions not to
intubate, no heroic measures.

His ashes we will bury in the garden between the
purple clematis and Cecil Bruner climbing rose just when
its pink blossoms will be blooming. We will bury him
between orange lilies and Solomon's seal, behind the
old grapevine my grandparents planted there 60 years
ago entwined with Spanish Ivy, its trunk as thick as a
stonemason's arm.

Tony

And today, on this Father's Day, we will sing a song over him and weep for him, at least remember him, and love him as best we can.

WRITING THE TRUTH OR THE TRUTH ABOUT WRITING

Writing the Truth

It is like I am lifting up a rock and looking at what crawls out from under it.

Some things are creepy crawly.

I fear the tone is maudlin, self pitying. I keep looking, regressing, returning, revisiting, reliving.

I keep looking. Every day I look again.

I switched to painting because painting was now.

Painting was a lemon on a white table cloth.

A golden hill catching the sun's light.

The shadow of this eucalyptus on this road, at this time of day.

Writing the truth means traveling back in time, unearthing buried secrets, holding up to the light things I am still afraid to talk about, things I still don't understand.

Why do it?

In times of grief, I turn to words. The words prophets and poets have written to cross the dark waters

of our terrors, longings, lost dreams, our grieving.

We sing songs in the car and tears stream down our face. Why? Deep feelings have been released.

The power of the word. I read a poem by a woman I never met about an experience I will never have and feel she is talking to me, taking me by the hand across the waters, placing her hand on my brow, comforting me.

Sometimes writing takes you to places you don't want to go, unbidden, hard to leave. But the words become candles lit one by one in darkness until the darkness is no more.

Replacing fear with peace. Replacing darkness with light.

Building a bridge for someone else to cross over.

That's what I want my work to do.

I want to light a candle for you so that together we can make our way through the dark places.

THE FIRE

The Fire

On June 21, 2008 a freak lightning storm passed through and sparked the fire that came to be known as the Basin Complex fire. Thousands of acres burned. Over 1,400 structures were threatened with dozens of residences and other buildings destroyed. Nearly 2,000 firefighters from all over the country came to Big Sur to fight this fire. During the worst of the fire, there was a mandatory evacuation and residents had to leave their properties.

Tom and my brother Kirk with a skeleton crew held down the fort at Nepenthe, keeping watch and feeding the firefighters. I took Emily back to school in Santa Barbara and came back to a closed highway and hundreds of displaced neighbors gathering at the Red Cross Shelter in Carmel. Nani came down from Oakland to help, trying to get help to our crew who are sleeping in their cars or on cots in the shelter, or staying with friends and family

Drinking From a Cold Spring

in Salinas, Santa Cruz, San Francisco, wherever they can find a bed.

People open their homes to strangers, taking in families for who knows how long? Others arrive with bags of groceries, clothing, bedding, phone cards, money, offers of jobs, anything they can give to help people who have left everything behind and don't know if there will be anything to return to.

We hear that Sula's house has burned to the ground, with everything she owned in it. At night at the community meeting I am talking with a man about his property above Ventana, about his efforts to save it, and only realize as he walks away that he could not stay to save it, that it has burned to the ground, that he has lost everything.

My friend Susan Thacker takes us in. Nani and I stay up late talking into the night, then sleep side by side in Susan's bed like we did when we were children. In the morning we wake up with the sunrise, check our messages and the news on Susan's television.

We pick up coffee and arrive at the shelter early in the morning, stay until they lock the doors, waiting for the road to re-open, waiting to go home.

LETTERS FROM AFTER THE FIRE

Letter From After the Fire

Doves circle the canyon where you write, and here Condors seeking fragments of prey. During the fire, no one could get here. Now, tourists return, the parking lots are full, bikers and biker chicks and their bikes rivaling the racket of the helicopters dumping water on return burn. Smoke re-fills the air and German tourists stand in bright Bermudas gawking, binoculars pressed to eyes. Home to water roses, ready to nap, ready to rest.

•••

Smoke hollows out the canyons and above Ventana flames in the basin of the creek have died low. Here, tempers flare.

Condors swoop, circle, drop into deep cool canyons, Germans circle Londoners in the parking lot while Hollywood agents slide into the spots in their mini micro

cars, locals flipping off tourists who pass on blind curves. The fire is 100 per cent contained, which means the perimeter, which means inside the perimeter the burning will continue until first rains fall. Smoke still saturates the air sometimes.

But today the sky is blue, the light is sparkling off the pepper trees, pink blooms on the hyndrangea which once was blue.

WALKING THE ROAD AGAIN

Walking the Road Again

Last Monday I took a walk south along the highway, delivering a letter to a friend at Deetjen's.

Tom said, "They are staying in the room called Catastrophe or something." Turns out it was Chateau Fiasco.

I left the letter and walked back up the road, through mists gathering over Packard Pond, past a woman playing guitar in the back of her Volvo wagon, dodging clusters of on-coming Winnebagos and Harleys and locals driving too fast and late for work.

The fires have passed. Summer is here. German tourists stand in pull-outs peering up at vultures they think are condors through expensive binoculars. Families picnic in crowded parking lots only minutes away from pull-outs perched over waterfalls that flow into the sea.

Hawks and sparrows and crows and vultures circle

Drinking From a Cold Spring

through the canyons below the restaurant's decks and stellar jays and mourning doves and small song birds await us on our morning walks. And some mornings we see three or five of seven condors sunning themselves on the trees at Wild Bird at Grimes Point, lifting their wings to the warmth and light of the rising sun.

We see more rattlesnakes now, more deer, more skunks (they come 10 to a litter and can spray 6 times in a row, by the way) and fewer raccoons.

Tom has been up early photographing the mists through the trees. He calls this new series of black and white work, "Coming Home, Dreaming of Big Sur." It is haunting, and eerie, a kind of devotion.

And in my painting I have retrieved memories of golden summertimes and find images emerging through brushstrokes. I remember when we were very little and summers felt like they lasted forever. Jack Curtis read poetry on the red terrace at Nepenthe one summer and described the hills as "tawny like the backs of lions."

The hills are not summer's tawny gold now, but deep plum and charcoal and rust, burnt and singed and bare of scrub, but gorgeous and strong and - above all - still there.

THE POWER OF LIMITS

The Power of Limits

In my family we make a lot of things by hand . . .
loaves of bread, sweaters, paintings . . . it is a
legacy from my grandmother Lolly, who even made the
adobe bricks in the fire pit at Nepenthe by hand.

During the early years of building Nepenthe, Lolly
scavenged lumber from abandoned barracks at Fort Ord
and reclaimed them for outbuildings.

Christmas tree ornaments were made from old
tin can lids, beaten with a ball peen hammer until they
shimmered like coppery discs.

Creativity is sparked by limitation. With no extra
money at hand, you scavenge or make something or go
without it.

Isolation plays a hand in the creative process as
well. Lonely winter months at Nepenthe found the crew
sitting around a table with yarn dumped out between
them, knitting away while waiting for the next customer
to blow in.

Drinking From a Cold Spring

The colors of Big Sur were always an inspiration - the rust and green and fuchsia of ice plant, the rich green grey greens and blue greens and heathers of the hill sides in winter, the blue swathes of ocean and sky.

When you start really looking at color, you begin to see it everywhere. Just now, Kaffe and I were sitting having a nice chat on the couch and I saw his eyes wandering around the room.

"Look at that!" he exclaimed, pointing out the juxtaposition of colors and shapes that had caught his eye. I looked around to see what had so delighted him, and had to laugh. It was nothing special, just an orange mop handle leaning against a red table, near a stack of saffron colored boxes.

When I know someone is coming, I take care to put away the drab and dreary, laying out a special cloth on the table, a beautiful jar of flowers on the mantel. They may not notice, but even so it is a way of taking care of people and attending to their surroundings. Doing this is my treat to myself after hours of working, because in the work (painting, writing) it is not always clear that I have done anything. But when I clear off a space, or change the color of the cover on the couch, I see immediately that I have done something good that lifts my spirits, and brings beauty wherever beauty can be.

•••

I could not paint. I could not find the inspiration, or the time, or the juice. Everywhere I looked there was too much to do – laundry, dishes, filing, bills, laundry.

The Power of Limits

Did I say laundry?

Then a funny thing happened. I took a day off to catch up with myself. I focused on opening up spaces, removing clutter, boxing up books and clothes to give away, making decisions about what to file and what to toss.

As the day went on, I began to notice the beauty of what was left behind . . . the glow of yellow lemons against a blue coffee cup, the sharp green of an apple casting its shadow on a white cloth.

With some breathing space around me now, I pulled out my palette and set about painting and painting and painting and painting and painting and painting

TAKING BACK YOUR TIME

Taking Back Your Time

Who says it has to be this way? We are all running around, too busy to breathe. Last night after a marathon day of bringing order out of chaos, I said, "I think it's time to stop saying 'Yes!' to everything!"

Tom laughed. "Yes I think you've discovered this before."

So what happened? Why isn't the lesson learned so that we don't have to repeat it - again and again and again. Debra Szekely, founder of Rancho La Puerta, says "plan your week before your week plans you."

Trouble is there is so much I want to do - so much I must do - that the week gets jammed full again before I've even enjoyed one planned week.

One way to look at it is that saying "no" is really saying yes - saying yes to being more engaged, more fully present, for what remains on one's list.

Drinking From a Cold Spring

When I teach painting, I ask my students to design their pictures before plunging in - identifying no more than five major shapes that create the key drama and interest and story of the painting. It is perhaps the hardest – and best – thing I can teach. It is our nature to get complicated. It takes some discipline to stay simple.

"How do you make such simple paintings that aren't just boring?" one of my students asked me a few weeks ago. That's the fear, I think, that if we simplify we will be bored. We will have nothing to do. We may have to just sit and be quiet for a minute.

This so rarely happens in my life that I realize it must be something I am avoiding at all costs.

So this week I am inviting this quality back into my life. Shutting one door – over-scheduling, over-activity, over-committing – and opening another. I am hoping this door will lead me into a room where peace and harmony and balance reside and are drinking tea and reading quietly in the early morning light.

As I write this, it is late afternoon. Light streams over the house across the street. Wind moves through the branches of the pepper tree, the tops of the hydrangea, the stalks of calla lily that grow here. There is a feeling of quickening, of spring, and I know that a part of what I am feeling is this cycle of life awakening to itself.

I set aside the morning to go outside and paint.

That's it.

Only thing on the list.

Just go out and paint.

Taking Back Your Time

And here I go!

•••

I spent the morning in a pull-out looking across Monterey Bay at the Santa Cruz mountains, softened by haze, exploring the dark silhouette of cypress trees and the rounded forms of red hot pokers, the dash of magenta ice plant and the fall of greenery over rocks and sand.

As I painted, shadows grew long. Sailboats dashed across the water. A man sat on a bench beyond the cove. Then he went away. A couple sat at the same bench and had a picnic, then strolled hand in hand until they were gone from view. A woman from New Zealand stopped to talk colors, and a couple from Japan politely asked to take my picture.

It was a lovely morning, time and space swelling like the breezes in the branches of the trees, lifting and moving as I pushed and pulled paint across canvas. Now and then I stopped to walk away and look back from a distance. Slowly a painting began to emerge.

For some a painting is a souvenir of a place. For others, it is a touchstone of a discovery. For me today this painting is kind of memento of a revelation that, at least this once, time is mine for the taking.

SUNDAY NIGHT MY MOM BAKED A PIE
. . . A cherry apricot pie for dessert

Sunday Night my Mom Baked a Pie

The pie had squares of sugared pastry dough scattered on top and no bottom crust, just tart and sweet jammy fruit, served hot out of the oven.

"The apricots were so tart," Holly apologized. "But there were these sweet cherries I thought would add enough sugar."

The lack of crust put the focus on the fresh ripe fruit. The bold flavor of apricot just off the tree was tart enough to make you pucker but just right.

Painting this weekend was like this one perfect pie Holly made for Sunday night dinner. Each painting was a grab for the essence of cool shadow, dark tree, bright branch, warm sky, thrown together to create balance, harmony, surprise, and delight.

Some paintings are like an okay apple pie you might get at a Howard Johnson's. You know what you'll get each time you order it. For me, painting plein air

Drinking From a Cold Spring

is all about not knowing, the surprise of looking that
yields unexpected fruit, the purple blue shadows hidden
in a green grove of eucalyptus beyond a swathe of
golden pasture I never would have seen if I hadn't been
staring at them, paint brush in hand, for hours.

Sometimes a painting comes home only to be
scraped down, the canvas or board readied for a new
attempt on a new day. But the experience is not lost - it's
come into how you see, each place you've painted now
a new friend, its unexpected beauty revealed and not
quickly forgotten.

Back to Holly's pie. William ate his piece of pie but
mostly concentrated his attentions on the sugary flakes of
crust. "Can I have another piece?" he asked very politely,
promptly digging into the topping on that one as well,
leaving the filling for me. I didn't mind.

We ate as much of the pie as our bellies could
hold. The next morning it turned up as breakfast for
Nepenthe's early morning clean up crew. I couldn't believe
we'd let it go – but it was meant for sharing. Like art, best
not to hoard it.

NOW

Now

It is late afternoon in Monterey, light glowing
through the green hydrangea leaves outside the
window. A burgundy red pick up truck is parked just
beyond in the shadow of the pepper tree. The shadows
are lavender on the white picket fence. It is so hot the
street is shimmering.

Now a breeze moves off the bay below and the
long leaves of calla lilies move like they are taking quick
breaths.

We woke up early this morning, walked three miles
toward the soft purple mountains that looked like a wash
of watercolor melting into the sea. I painted a quick
sketch, washes of cool hues on canvas, then drove into
town, into the heat of the Carmel Art Festival and 100
degree days and scores of people and high hopes.

Now the festival is over, the heat has passed. Now it
is Monday and fog has moved in and the air is cool. I look

Drinking From a Cold Spring

at the sketch of soft mountains and remember those hot days, remember the prayers I prayed – for guidance, for understanding, for inspiration.

The sketch is rough, unfinished, crude even, but when I hold the painting in my hand I see 7:30 AM in Big Sur on a day that will become unbearably hot, on a day when I will drape a wet cool cloth around my neck and pull a hat over my head and go out into the wildness of the coast and paint my heart out.

A painting can bring you to a place you remember, and it can take you to a place someone else has been that evokes memory, emotion, longing.

My son Chi has a painting, Studio Apartment, that I love. This piece takes me to a cool room overlooking a quiet city, a place where I can imagine sitting with a cup of coffee and a notebook and beginning to put words on paper, a place where everything is where it should be, and there is time for everything.

The original Studio Apartment is a gouache on paper – one of a series Chi did last year. He painted this before he moved to Brooklyn when he was living in a tiny one room studio in Big Sur. The room was so small that half of it was a bed. When Lorissa moved in, she set up a tent so she could have a room to write in, and built a little outdoor kitchen on the lee side under a tarp.

In a way, Chi has created in this painting a room for us all to walk into, a place of spaciousness, of order, and of peace.

WHERE DOES IT COME FROM?

Where Does it Come From?

Many years ago after a long afternoon painting out of doors, I came back to the studio and emptied my palette onto a fresh canvas. I was hot, tired, hungry, but there was an idea that had sprung up driving home that felt important - something about being a kid in Big Sur, getting dropped off at the end of a dusty road to spend the day with a friend, walking up the road what felt like miles and miles, finally seeing the house in the distance, heat shimmering across the valley, the promise of a cool drink, shade, rest, and most important a friend to play with.

The painting that emerged was "Childhood Memory," a simple motif of house and trees on a mountain top. Perhaps of all the paintings I have ever done, this is the one people comment on more than any other.

"Where is this house?" they ask, and then they say, before hearing my answer, "I *know* this place!" and tell me

where the painting takes them in THEIR memories.

Sometimes it is a cabin in North Carolina, or Virginia, or the Marin Headlands . . . sometimes it is a house on a hill in Big Sur, or upstate New York, or Western Canada.

Somehow this image, more a waking dream than a memory, connects a sense of place and time that is meaningful to me with a sense of place and meaning in other people's lives.

This is a mysterious and powerful thing - it has made me return to this painting, studying it for clues. Why does it resonate? Where did it come from? Why did it speak volumes where the work I did "from life" that day eventually ended up painted over?

I ask myself, what was the state of mind I was in that evoked the memory and the visual information that led to the painting? How did I get into that state of mind or being? How can I get there again? How else does it occur?

I've noticed that I find that place through painting in the morning, after walking and before making phone calls, before my brain has become saturated with "must do's" and organizational details.

I find that place after waking from dreams and before jumping out of bed. I used to keep a dream journal to record images and words and re-read them to find recurring motifs.

Climbing up and descending mountains was a frequent dream-image. Not surprisingly, the image of the

Where Does it Come From?

mountain recurs in my paintings. At first these were literal places - the hills east of Nepenthe, Soberanes Point, Point Lobos. Lately these hills and mountains have become more abstract, unmoored from the local, evoking a sense of what is beyond place.

When this state of "flow" or grace is very strong, I want to paint and paint and paint – I don't want anything to interrupt me, and will wake up early and stay up late to stay with the energy. All other obligations fade.

And sometimes there is no sense of flow – it is just habit and tenacity that keep me at the easel, or jotting down ideas on scratch paper while in the car waiting for the light to change, and only later that the idea and the inspiration and the time and the materials will come together as a painting.

When I was a young mother, 19 years old with a baby on my hip, I used to write verses while stirring the soup or at the laundromat – thinking it would be easier to get the time to really write when my son was older, when there was the time to create without interruption.

What I have found is that you have to make the time to create a priority, you have to guard your energy so you can have access to it when you have the time to use it, and you have to figure out a way to do your work even when you don't have the luxury of uninterrupted time.

With "Childhood Memory", part of what worked for me that day was that I'd been painting for hours.

So I was warmed up.

And I had already finished my painting time for the

day. I just wanted to clean my palette. So there was no pressure to "perform."

I had a simple idea and I painted it quickly, and because it was the end of the day and I was tired I didn't mess with it, just left it alone and went home to wash my brushes. It was only later that I began to see that the painting was actually finished.

ENOUGH!

Enough!

Today was a day of lists. Half way through I found my energy gone but not my list. I had only checked off a quarter of the things I had set for myself.

Quickly I drew an arrow next to one thing - "to Tuesday," I wrote.

Then I evaluated which thing I would most regret NOT doing. That would be exercising. I set my timer for 30 minutes and did my sit-ups. That nearly killed me so I went out to the garden to water, a way of doing nothing while doing something. Some friends wandered by and wandered in. We sat and talked and laughed.

Why am I so tired? When they left, I went back to my list, crossed off "exercise," and then moved one more chunk (4 hours of painting) to another day. Not going to happen today. Can barely keep my eyes open.

I thought maybe today was meant to be a day off and

Drinking From a Cold Spring

I just didn't get the memo.

Why am I so tired? I wondered again. Then I looked back at the previous week(s) and the upcoming week(s) – getting back to work after the fire, and hanging a new show on the heels of an art opening, and then another opening and a new class I'm teaching and scheduling Fall classes . . . then there are the kids, with doctor visits and school schedules and wedding plans . . . and I am suddenly aware that I have been holding my breath waiting to get back to normal.

I have been waiting to get back to normal, when everything is settled down again. I have been waiting until everything is not falling apart or blowing up or burning down or changing. And that moment, actually, will not come. Because it seems we are always on our way to or from some new challenge or disaster or catastrophe that IS life-as-we-know it.

This morning, walking, we saw two black birds flying overhead so close their wings tapped together. When I sat down to write, a pod of whales was swimming right below my window, 800 feet down. The fog lifted a while later. Light bounces off ripples on the sea.

Maybe getting back to normal is not the point at all.

Maybe just experiencing this - now - the robins' wings tapping on the downbeat AND the feeling of exhaustion, emptiness – in the midst of all the chaos and change and lack of clarity – is enough.

BIG SQUEEZE, LITTLE SQUEEZE

Big Squeeze, Little Squeeze

My nephew Will, now 6, stayed with us over the weekend. That meant Sunday we got up early for pancakes and hot chocolate ("dessert for breakfast!") and a drive to Pfeiffer Beach.

We drove through Sycamore Canyon with Will narrating each twist and turn. "This would be a great place for chickens!" Will said, face plastered rapturously against the window. "Look at all those ferns, and trees, and rubbish, and stuff."

I am thinking rubbish wasn't the word he was looking for. I am thinking he was looking for a plant or shrub or tree word. With so many new words he is learning every day, a mix-up here and there is understandable. We went on to name a lot of things that a chicken might like to peck in the dirt – grubs and worms

and seeds – and then we were pulling off our shoes and running through sand soft as velvet out toward a bright gray sea.

We got as far as the second cove before dropping to the sand to build a castle - complete with tower and moat, extra parking, a lavender field and underground rooms, finally a gift store and pub which became a pyramid as we relocated our fantasy abode from England to Egypt.

As we added a curving path around the castle grounds we watched three men ditch their trousers to brave the crashing surf and hurriedly scurry back again upon realizing that the water was literally freezing.

And suddenly it was time to go - the bright morning sky darkening, time to buy the Sunday paper and shape the loaves of bread we had left to rise at home and to start thinking about what we going to cook for Sunday night dinner for the rest of the family.

On the way back to the car we saw a lone seal slide out of a wave onto the beach and then wiggle back into the surf again. Overhead five hawks twirled. We stood for a while and watched the seal moving in and out of the water, and watched the light hit the black rocks wet with spray and the dark clouds moving in.

"Race you!" William said as we turned to go, for real this time. He gave me a ten second lead but beat me back to where I'd left my shoes anyway. I'm sure he thought I was letting him win. Then he put his hand in mine and gave it a little squeeze.

Big Squeeze, Little Squeeze

This has been the year of the big squeeze for so many of us - so many things have fallen apart and are falling apart. But it is the little squeeze that will redeem everything, I think. A little hand reaching up to a big hand. A little trust and a lot of love, pancakes for breakfast, and Sunday night dinner with my family.

SACRED SPACES

Sacred Spaces

So much of our life is woven around home - the garden, the kitchen, the cats on the couch.

Home is our hub, with the kids home for a weekend, Sunday night dinner with the family, the rhythm of the restaurant below us anchoring us in our own work rhythm.

After a few weeks on the road this winter, I was welcomed home by the most extraordinary feeling of space, of beauty, of light and openness. As we walked our early morning walks, I marveled at the beauty of Big Sur and the sense of light and the incredible calm here.

This has been a mad year. It seems as soon as things calm down a bit and I say "now we're getting back to normal," something shakes out again and we are off and running. Sometimes I feel like I am holding my breath – as though there is a place I am trying to get to – or get back to where I will be able to relax and re-establish my

routines.

Coming home this time seemed to reawaken my awareness of what it is here that gives me that sense of connectedness, of refreshment of the soul, of spaciousness. It is the sense I get, also, when I am walking on the beach, or meditating, or when I am re-arranging a space and have placed a beautiful vase on a colorful cloth in a corner where my eye will rest as I move between rooms.

A few weeks ago I was in Los Angeles working with my dear friend Catherine on a show of art and home decor. We were both working to deadline, arranging spaces to convey the maximum amount of beauty and enjoyment before our guests arrived. As the sun began to go down, Catherine came around to the front of the house and set a standing Buddha on a pedestal near the entry way.

Suddenly the anxiety of getting everything ready on time for our guests dissolved. The Buddha seemed to bring a sense of rest and peace to both of us. This Buddha, no more than 18" tall, gilded wood, eyes closed and hands clasped in prayer, told me we had done enough, that we were ready, that it was time to stop preparing and begin enjoying.

I was struck in that moment, which came after months of planning and two days of driving, insane traffic, packing and then unpacking boxes of artworks, hanging and re-hanging work, plumbers fixing broken drains and electricians hanging lights and caterers

Sacred Spaces

unpacking wine glasses, that we have this power to create sacred spaces in the midst of all this chaos, and that this is one of the things that a work of art does. *For* us.

A painting on a wall can be a window into another world - perhaps a world of serenity, of beauty, of peace. It's really our choice - these images we bring into our home, the way we honor the spaces we raise our children in, cook our meals in.

A painting or a beautiful object holds the power to heal our hearts, to give us refuge, to calm us down and ease our spirits.

I'm home now catching up with the garden and the cats and my sour dough starter, and painting new paintings. And Catherine's Buddha has come home with me, standing guard in a niche by the front door to remind me to find that peaceful place within myself, and that in finding that place my work will find its power and its purpose.

TURNING THE CORNER

Turning the Corner

Thinking of these hard times now, I was remembering where we were twenty-five years ago.

Tom and I had just gotten married and were heading east, making our living selling jewelry at country fairs. Our plan was to make enough to spend Christmas with Tom's folks in New York City, then buy Eurail passes and bum around Europe for a few months, and see what the future would bring.

Things didn't work out that way. The weather went south, the country fairs were a bust, and our bank account dwindled.

It was just before Christmas when Tom and I (and our nine month old son) broke down in New York City, about $700 to our name (and a lot of feather ear-rings), everything we owned including our dog Amber stashed at Tom's sister Meg's house in New Jersey or in the

back of our pick-up truck which was now stuck on the intersection of Broadway and 57th with a broken axle in the middle of a sleet storm.

Tom called AAA and stayed behind to get things worked out while I loaded our bags into an off-duty cab and headed over to the apartment where we were hoping to stay on the east side of town.

I was nineteen - one of the many things I didn't know then was how to pack. One of my bags fell into the rain gutter, balls of yarn tumbling into the icy sludge. The doorman stood there in the warm well-lit foyer of Tudor City with his arms crossed, watching me with Chi in the Snugglie chasing the yarn, paying the cabbie, pulling bags out of the trunk and trying to carry everything (baby on front, back-pack on back, bags of wet dissolving paper on the one hip, a suitcase on the other) into his building. I imagine he was in denial. Surely WE were not coming into HIS building!

Tom didn't come home for hours. Getting the truck towed to a garage was a story in and of itself, and getting it fixed cost almost exactly the amount of money we had in our bank account.

We had Christmas with Tom's mom and dad and brother and sisters. Everyone was very kind. But I was very sad. Nothing was as I had imagined life would be. At that point, we had zero dollars in the bank, nowhere to live, no jobs, student loans to pay off. I don't remember if people asked us what we planned to do. I don't know what we would have said if they had.

Turning the Corner

We headed north, our last dollars filling up the tank. At some point Tom's mom gave us a check for $1000 toward getting his wisdom teeth pulled. A kind way of helping us, without injuring our pride.

We took that money, put a first and last down on a house in Saratoga Springs, filled the tanks with heating oil to get us through the winter, and set about trying to find work.

We couldn't even find a job pumping gas.

I could not imagine going home or asking our families for more help. I felt like we had got ourselves into this fix, now we had to come up with a way out.

We had to find work, and fast. Tom thought he could get a job further north, in Burlington, Vermont, where he had lived a few years back. We drove north in a blinding sub-zero snow storm with the last of the wisdom teeth money to a friend's house where we slept on the floor.

A few days later, Tom found a job at a restaurant and a house we could afford near a park and a mom and pop grocery store. A few days after that, a paycheck, gas in the truck, food in the fridge, heat on, diapers, even a few dollars left over.

I wrote a hardship letter to our landlord in Saratoga Springs asking for a refund on our last month's rent and for the value of the oil we'd put in the furnace. He sent me a check a week later (the first money I made from writing) and then I got paid a $100 for a story I'd written for Glamour Magazine during our week in Saratoga Springs. I knit a few sweaters and sold them. Eventually I

found work in a bakery downtown that got me back to the house just before Tom went off to work.

And we got through that winter. We both worked hard and took turns taking care of Chi. During the long cold dark months we talked about going home to California, or saving up for that trip to Europe.

But when spring came, we decided to stay on. Because this was where we found out who we were, what we were made of, and because this was the place were we turned the corner.

I am grateful to our family for helping us without punishing us for making mistakes. To our friends for sharing with us what they had even when they had very little.

The things we learned during that long year twenty-five years ago are the things that have made us strong as a couple. They are the lessons that I have drawn from in making a life as an artist. They are the lessons I go back to every time I hit a corner. And they are the lessons I try to pass on to my kids.

So in these hard times, here's to digging deep, working hard, and to turning the corner!

COLOR THERAPY

Color Therapy

Someone once suggested to Henri Matisse that he must be a very happy man, an inference drawn from the color and tone of one of the artist's paintings. Matisse replied that he was in despair when he painted the particular work in question, hungry and broke and generally at the end of his wits.

The painting then was not a reflection of what we would call ordinary reality. It created a new reality, a place of hope and happiness and inspiration that continues to touch us even today decades after its creation.

I am thinking about this today after working with my uncle Kaffe and experiencing his particular brand of art making. Color, pattern, light - an immersion into a kind of heightened reality, inspired by nature but not constrained to the ordinary.

Kaffe sees (and helps us see) ordinary things in an extraordinary way – the movement of pale pearl into

183

deep charcoal in a random pile of stones, the symphony of greens in a bank of road-side succulents, or the shift of chiffon yellow into grass green of an unripe banana.

In early December, the Pacific Grove Arts Center was our host for a third year of painting and color workshops. In spite of the space heaters, it was quite frosty and our group would show up each day dressed in many layers – hats, scarves, mittens, parkas over sweaters over long underwear. But in spite of the frigid temperature there was a sense of growing heat in the room generated by the high glowing colors of Kaffe's still-life and the intense concentration we felt entering into that world of color and expressing it on canvas. The paintings that emerged were anything but cold, transmitting light and warmth and a kind of ethereal beauty that belied the grey skies outside.

Kaffe's book-signing drew lines that stretched all the way out the door and filled the Holman's parking lot to capacity. It is gratifying to see that people are still sewing, still knitting, still making things to beautify their homes and with their own hands.

During his slideshow at Robert Down Elementary School, I sat in an audience of hundreds of busily knitting women (and a few men) and listened to Kaffe talk about his life in the arts, the healing power of color, and the value of art in bringing that healing color into our lives. And once again I was amazed at the simplicity and power of this simple act. And struck by the hunger we all feel for more color, more beauty, more meaning in our lives.

Color Therapy

Can you really change your life by switching your bed coverings from beige to sunflower yellow? Drinking water out of a sapphire blue glass? Wearing a pomegranate red scarf against the blues of a gray day? Yes, I think you can.

I came home from the lecture and looked around my winter-weary house. Gathering fabrics from the scrap bag, I sewed up new rose-strewn covers for my couch cushions, flipped an old quilt to its zingier absinthe green side, and commenced to amp up the color. On my next town trip I finally got around to replacing my dingy old bath towels with beautiful reds and rusts I found on sale at Marshall's. Now, at the end of a long day on the road, my house greets me with a sense of joy and welcome - the colors of springtime in one room, and Autumn in the other. What a difference it made to strip out the dull and dreary!

Kaffe reminds us of what we already know. We can ALL work in color - and it DOES matter.

Back to the studio!

WHAT MATTERS?

What Matters?

I was making Valentines last week with a friend, painting hearts with candle wax then splashing color across the paper.

"But I can't see what I'm doing," my friend said. "How do I know it's going to be right?"

"Because you've drawn hearts hundreds of times," I said. "Just trust it."

She closed her eyes, gripped the candle, then without hesitation pressed her candle into the paper. She studied the paper for a while. "I can't see anything," she said. Then she took a deep breath, dipped her brush into the paint, and flooded the paper with color.

And there it was - a gorgeous strong white heart in a field of fiery red.

The look on her face was amazing. She couldn't believe she'd done something so easy that came out so right.

Drinking From a Cold Spring

"Can I do another one?" This time, there was no hesitation. She dug in and drew hearts and stars and the name of her beloved until finally it was time for her to go.

Somewhere along the line we get taught that our efforts are wrong, that there is a "right" way, that trying something new might lead to a mistake and therefore we better not do it.

Who is it that tells us that it is better not to try than to try and fail?

I love working with kids because when class starts their first question is, "Where's the stuff?" Grown-ups are more apt to ask, "What do we do?"

I love working with grown-ups because the discovery of creative joy is so palpable and so healing. I love seeing someone do something they really truly thought they could not do and discovering that yes, in fact, they can!

That spark is within us all, each and everyone of us. Sometimes we just need a little help fanning the flame, and providing a little protection for it as it gains ground.

When I look back at things I've worked hard to accomplish, I ask myself, what mattered? Sometimes the answer I arrive at is a real surprise - not the big thing, the opus, the exhibition, the honor. Sometimes it is the little thing - sometimes simply the moment of connection with another person, igniting a spark, shepherding a flame.

Nurturing our connection with one another is something we can all do, in so many easy ways - like drawing a heart with wax on paper, it just takes a little

What Matters?

trust - that it will work, that it will be right, that it will matter.

It is a good practice to ask yourself, once in a while, what matters? And what can I do?

Then do it.

IT'S A MYSTERY

It's a Mystery

Life is mysterious. My parents split up a year before I was born and just happened to share one last night together. Tony suffered from hallucinations and vanished from our lives. Occasionally we received letters. I looked for him when I was too young to deal with what I found.

Twenty years later when I found him again, I was afraid. Finally I wrote him a letter, and he wrote back. After a year of writing letters, I was ready to meet him.

I visited him once a year for over ten years, and there were times when he wrote to me every week. I kept his letters in a woven green box on my bureau until they began to spill out and then moved them to a shoe box, later a manila folder in a filing cabinet. Most of his letters were no more than three sentences long.

In December he died, and in May we gathered to share stories of his life. His sister Bourne read a letter

Drinking From a Cold Spring

she'd written, her husband Bob, who'd known Tony as a teenager, was there as well. My cousin Nani came and read a beautiful poem, and my brother brought his wife Meredith and their son William. I think it was Meredith who said, "I never knew Tony, but I'm glad he lived because he gave me the most important people in my life."

Before my father died, I asked him what we meant to him - my mother, my brother, myself. It is hard to write his answer here, and strange to say that what he told me helped me understand something I've struggled with all my life. When I asked him this question, he said, simply, "nothing."

What I realized then, and have spent my life working through, is that our meaning does not come from something or someone else. It comes from the meaning we find in our lives, the meaning we make of our lives. When Meredith said that she was glad Tony had lived because he gave her the man who is her husband and through him the child who is her son, I was filled with gladness too, and thought of my own life and children, Tony's grandchildren, who are everything to me. And somehow her words lightened the grief I felt and let me feel gratitude for Tony's life, and helped me release whatever else it was I was holding out for.

SETTING THE TIMER

Setting the Timer

Today I am setting the timer and attacking my list in increments.

First there is the walk. Then the talk. We delay breakfast so that we can make real headway on a few projects we'd like to end today. I jump in to straighten up the chaos from the week and find myself completely confused about what I am trying to get accomplished today.

There seems to be too much to get done before I can even get started. Laundry. Dishes. Piles of paperwork heaped on the floors, beds, tables, chairs. Little notes scattered about indicating which pile is for me, or Tom, or to be archived, or a must do ASAP project.

Notes hang from the wall by Scotch-tape and tacks, interspersed with Valentines and thank you cards, art projects, our seller's permit and our budget. E-mails cluttering the inbox, clamoring for replies, snarky

messages from old friends wondering why I haven't Face-booked them.

Information overload!

We have to make a short list of what we really want to get done today, I say to myself. Let the rest go!

We sit down and go over our short list it fills five pages.

Enough!

I feel like we are wasting time and must begin. But I take a deep breath and as Tom goes off to fight his dragons, I put the timer on (15 minutes,) kneel, and take up a yoga pose. For fifteen minutes - to the second - I close my eyes, bring my breath back into my center, and find myself again.

When the timer goes off, I hit the ground running - organizing, purging, sorting, discarding, filing, moving one pile from the bed into a bin to be sorted later, hauling the trash to the door, finishing the dishes.

The timer goes off again - another yoga pose (10 minutes) and another round of work. This time 45 minute intervals.

The buzzer goes off, and I switch horses . . .

Today this is how it works for me, this is my process.

Through it all, a gorgeous pink heart swimming in a buttercup yellow sky leans against my keyboard, a memory of painting Valentines.

More of that!

SATURDAY
MARCH 21, 2009

today
i wanted not to rise to the occasion
not to get out of the bed
or go for the walk
or turn the corner
or be on the other side.

today
i wanted to swim below the surface
breathe the water into my lungs
just this once not find the bright side
just this once

today
broken promises like broken glass
i think i've swept away the shards
but the smallest needles are the sharpest
clinging, invisible until they have pierced the skin

today
i don't understand
don't rise don't cross don't turn
just keep returning to this broken place
can't mend it, can't tend it,
don't want it, am it

NOT DOING

Not Doing

This is the day I get to do nothing. Somehow I always find that after lolling about, long bath, coffee in bed, reading, crossword puzzle, letting clothes drop to the floor and NOT picking them up, playing with the cat(s), walking through the garden, getting back in bed, more coffee, NOT making lists, NOT answering the phone, I find that there is a surge of energy around a long forgotten idea and I begin to feel something quickening, and an impulse toward doing doing doing...

Which (because it is Sunday) I try to ignore.

Because it's all about "doing" the rest of the week, too much doing, have-to-doing, and can't-put-off-doing and should-have-done-doing. There's just got to be a day in here where that's just now allowed, when "NOT-doing" rules.

So I make a mental note – maybe I'll get on this bright new idea tomorrow – and light a candle, pour

Drinking From a Cold Spring

myself another coffee, sit down on the couch with
the kitties, Daisy and Miss Kitty, my Zen-gurus and
meditation partners, and read the paper.

Or not.

Because after all, tomorrow is a new beginning.

About the Author

Erin Lee Gafill's roots in the arts run deep. Her great-great grandmother was Jane Gallatin Powers, who had the first artist's studio in Carmel and who, along with her husband Frank, created the artist's colony which is today Carmel-by-the-Sea. Her grandparents Lolly and Bill Fassett built Nepenthe Restaurant in Big Sur, a legendary watering hole for artist, poets, writers, and bohemians.

Erin is the cofounder of Big Sur Arts Initiative, a nonprofit arts education organization dedicated to nurturing art and culture in the Big Sur community. An award-winning writer, painter, and teacher, her work is collected internationally.

In 2001, Erin was honored with an invitation to be chosen as the first American artist-in-residence of the Hamada International Children's Art Museum, Hamada, Japan. Works from this trip were displayed at the Monterey Museum of Art.

Erin's work is currently available through, Left Coast Gallery, Studio City, CA; For Love of Home, Brentwood, CA; Carmel Bay Company, Carmel, CA; Local Color, and the Phoenix Shop both in Big Sur, CA and by appointment through her own Studio One in Big Sur.